THE LITTLE BOOK OF

Lettering &

WORD DESIGN

MORE THAN 50 TIPS AND TECHNIQUES FOR MASTERING
A VARIETY OF STYLISH, ELEGANT, AND CONTEMPORARY
hand-written alphabets

Brimming with creative inspiration, how-to projects, and useful information to enrich your everyday life, Quarto Knows is a favorite destination for those pursuing their interests and passions. Visit our site and dig deeper with our books into your area of interest: Quarto Creates, Quarto Cooks, Quarto Homes, Quarto Lives, Quarto Drives, Quarto Explores, Quarto Gifts, or Quarto Kids.

First published in 2018 by Walter Foster Publishing, an imprint of The Quarto Group. 26391 Crown Valley Parkway, Suite 220, Mission Viejo, CA 92691, USA. **T** (949) 380-7510 **F** (949) 380-7575 **www.QuartoKnows.com**

Walter Foster Publishing titles are also available at discount for retail, wholesale, promotional, and bulk purchase. For details, contact the Special Sales Manager by email at specialsales@quarto.com or by mail at The Quarto Group, Attn: Special Sales Manager, 100 Cummings Center, Suite 265D, Beverly, MA 01915, USA.

ISBN: 978-1-63322-471-1

Digital edition published in 2018
eISBN: 978-1-63322-472-8

Page layout by Elliot Kreloff

Printed in China
10 9 8 7 6 5 4

MIX
Paper from
responsible sources
FSC® C017606

Table of Contents

OPQ Z
KABC &al

INTRODUCTION

Welcome to the wonderful world of calligraphy, lettering, and word design! This book features a variety of step-by-step lessons, techniques, and tips for learning the art of traditional calligraphy, contemporary hand-lettering, illuminated lettering, doodled letterings, and even how to make lettering art projects using watercolor and gouache paint. You'll learn all about the basic tools and materials you'll need to get started, while a variety of lettering templates and open practice pages invite you to master your skills while you learn. Let's get started!

xyz E LMN

Piano hij
m

PART I

Traditional Calligraphy

TOOLS & MATERIALS

You have many choices when selecting writing tools for hand lettering. Pencils are often used for layout, but a pointed brush, broad-edged brush, pointed pen, broad pen, ruling pen, parallel pen, and markers can be used interchangeably, depending on your skill level. Although you might expect to remove a tool from its packaging and have it work exactly as you'd like it to, some tools have to be modified or prepared to achieve specific lettering effects.

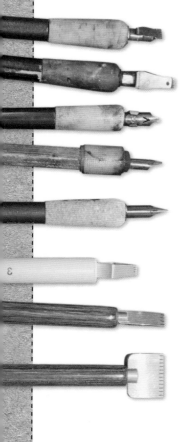

PENS

Broad-Edged Pens

This may be the easiest tool for beginners. It's popular because of the natural thick-and-thin ribbon it makes. Broad-edged pens come in the form of dip pens for calligraphy, automatic pens for larger letters, and fountain pens. Broad-edged pens (sometimes called flat pens) can be used for many of the styles in this book; however, you may have to manipulate them to achieve some of the desired effects.

Ruling Pens

This is a forgiving tool and can be quite fun. A ruling pen has a knob on its side that you turn to move the blades closer together to produce a thin line, or farther apart to increase flow. They create forms that seem random and free—the opposite of traditional calligraphy. You can vary the weight of line by changing from the side to the tip. You may choose to purchase new ruling pens, but you can also find a variety of shapes and sizes in antique stores. The downside is that you must learn to put the components together correctly or you could end up with a mess.

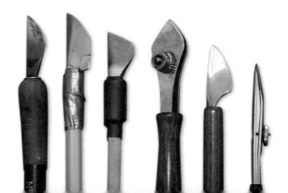

Pointed Pens

Pointed pens do not automatically produce thick and thin lines, but rather rely on hand pressure to produce variation in line weight. Pointed pens are made from different metals and have varying amounts of flexibility. This pen can also be used for informal work, but the downside is that it takes time to learn to control. Line-weight variations depend on adding and releasing pressure, so the nibs have a tendency to catch on paper fibers and splatter.

INKS & PIGMENTS

Inks and pigments fall roughly into dye-based, pigment-based, and carbon-based categories. Carbon and pigment come mixed with water and binder. Some are waterproof, but they use a binder that is not generally good for your tools, so be careful. Carbon-based inks are permanent, as they don't fade over time. Dye-based inks should be used for practice because they are loose, which can lead to an interesting effect in writing. They will not clog your pen, but your work will fade over time.

Other pigments you can use are gouache, watercolor, and liquid acrylics. Gouache and watercolor are similar, although gouache is more opaque and dries to a velvet flat finish. Watercolors are transparent and ideal for showing some variation in the color.

BRUSHES

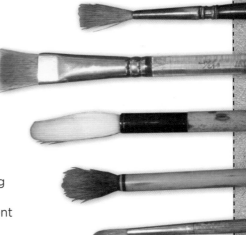

Pointed Brush

The pointed brush may be the most versatile lettering tool available. It comes in a wide variety of shapes, sizes, and bristle lengths. Like the ruling pen, the pointed brush is a wonderfully expressive tool open to wide variation. The characteristic "brushmark" is highly desirable. You can create work that has interesting texture and line with little practice, yet it can be challenging to exert control and produce consistent work.

Broad-Edged Brush

The broad-edged brush is a versatile tool good for surfaces that are not pen friendly, like fabric or thin Japanese paper. It's also a good tool for creating large letters, especially on a wall.

PAPER

Paper can be broken down into three categories: practice paper, work paper, and paper that renders special effects. Lettering artists put careful consideration into the paper they use for their finished work. (The practice pages in this book are perfect for getting comfortable with the tools.)

Bond paper that is smooth and doesn't bleed is most useful for everyday use. For practice, you can use brown kraft paper or a cheaper bond paper (as long as it does not bleed). Higher-quality bond paper is worth the price.

Once you're ready to move beyond practice paper, you might want to try something durable with a slight "tooth," which may lend a nice quality to your letters.

Specialty papers include handmade papers, colored papers, and rough watercolor paper, which can be used to achieve interesting, textured edges or contours in your lettering.

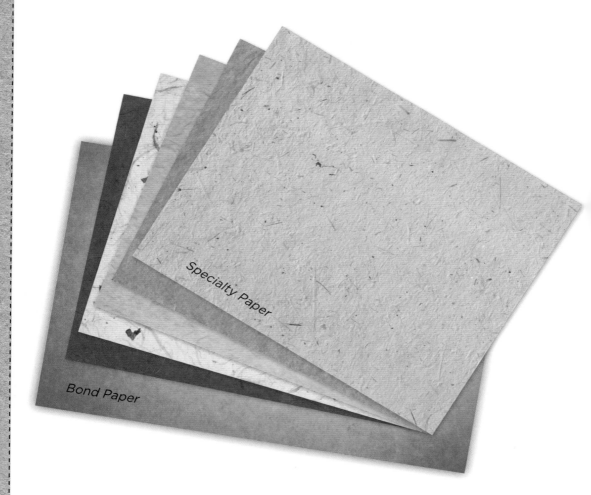

Specialty Paper

Bond Paper

EXTRA MATERIALS

There are several other tools you will want to keep on hand: pencils; felt-tip pens; erasers; a straight-edge (T-square); tracing paper; white gouache for retouching, if necessary; cutting tools; markers; masking tape; mixing trays and palettes; and smaller, inexpensive brushes for mixing colors and loading pens.

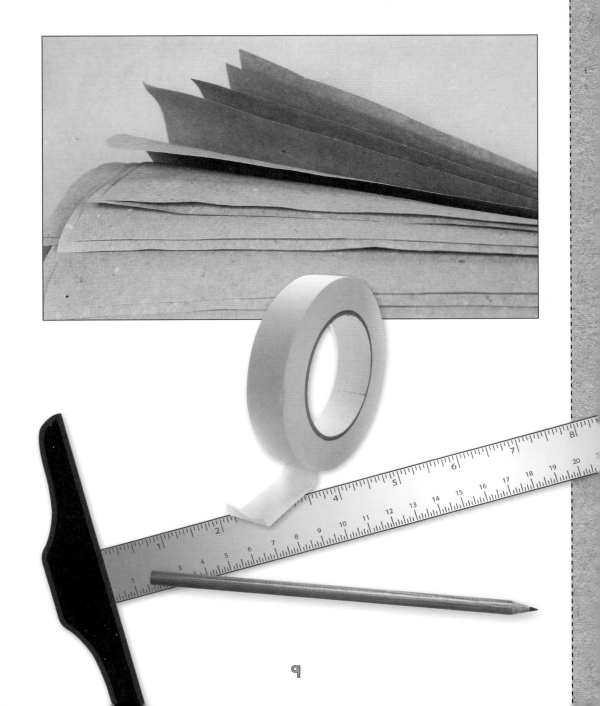

BASIC TECHNIQUES

The scribe of the past would cut a reed or quill pen, thus shaping the nib to his or her preference. You may find that you need to modify tools to your preference as well. As you master the techniques in this section, you will discover ways of modifying your tools that will make them work to your advantage.

Cornering *When cornering, use only the corner of the pen's nib to create a thin line or to fill in detail. This technique is often used for hairlines and sometimes for ending serifs.*

BROAD-EDGED TOOLS

With a broad-edged pen, start with simple, even strokes and hold a consistent pen angle. Even though many of the alphabets in this section are informal, you will find that it is helpful to use a T-square to draw straight lines on your lettering surface.

Broad-Edged Brush *The broad-edged brush is somewhere between the broad pen and the pointed brush because you can borrow influences from both sides. Use it as a broad pen or as a "hybrid" brush.*

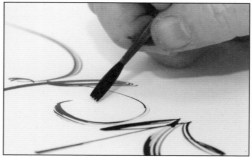

Broad-Edged Brush Hybrid *This is an example of using a drybrush technique with a broad-edged brush so the brush exhibits qualities of both a pointed brush and a broad-edged brush.*

RULING PEN

The ruling pen is a play tool for many, allowing you to make forceful marks and "rough up" the paper fibers. There is no right or wrong way to write with this useful tool.

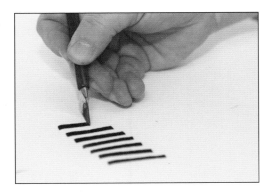

Folded Ruling Pen *The folded ruling pen creates a thin line when you work with just the tip, a thick line when you use its side, and every line variation in between as you move from one position to the other.*

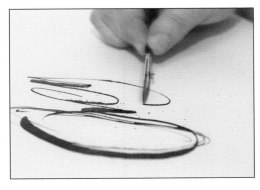

Experimenting with Marks *Although it is important to gain control of the ruling pen, the trick is to make the marks look slightly out of control.*

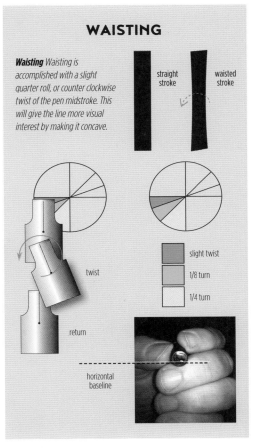

WAISTING

Waisting *Waisting is accomplished with a slight quarter roll, or counter clockwise twist of the pen midstroke. This will give the line more visual interest by making it concave.*

straight stroke

waisted stroke

twist

return

horizontal baseline

slight twist

1/8 turn

1/4 turn

POINTED PENS

This type of pen is associated with "copperplate" and Spencerian script, but it can be used for contemporary handwriting as well, especially when the tip has been modified. Putting a slight broad edge on a pointed pen and sanding it down with an Arkansas stone is one type of modification. Another way to change the effect of a pointed pen is by using the pressure and release method (below).

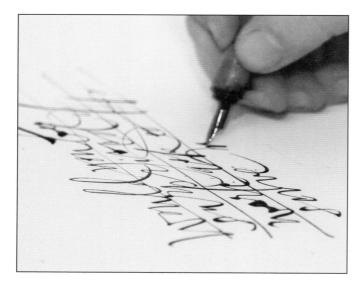

Flexible Pen *Traditionally, most calligraphy was done with either a pointed pen or broad-edged pen. Both create "shaded" lines, but they achieve the shading in different ways: A pointed pen employs pressure, and a broad-edged pen changes in direction.*

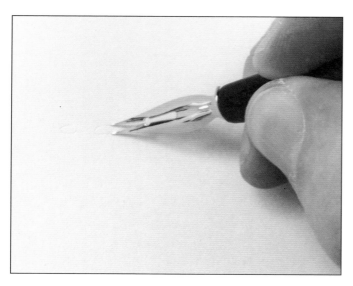

Pressure and Release *For this technique, add and release pressure applied to the point of your pen, which will spread and unspread the two blades. This motion controls the flow of ink onto the paper and allows you to create variations in line weight.*

POINTED BRUSH

With a pointed brush you can draw, paint, and write in a variety of media and on almost any surface. Direction, pressure, and speed all affect the line you make with the pointed brush. The brush can be held upright or on its side; you can work with the point for thin lines or the broader base for thick lines. Develop a feel for this tool by practicing a variety of strokes.

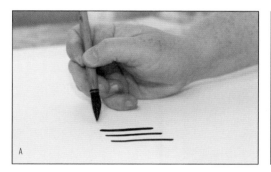
A

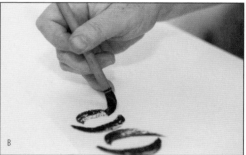
B

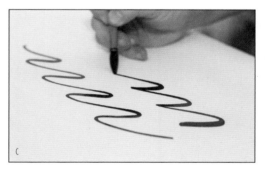
C

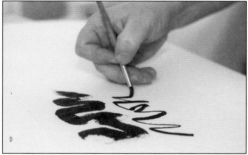
D

Pointed Brush Holds *These photographs show the common approaches to handling the pointed brush. You can work on the tip of the brush (A), work on the side of the brush (B), or use a combination of the side and tip of the brush (C). You can also create variation with pressure (D). There are different types of brushes, and the shapes, sizes, and bristles all make a difference. Both the paper you use and the method you employ to load ink into the brush will also impact the final result.*

Chinese Brush

The Chinese brush offers more variation in its stroke than other pointed brushes. Some Chinese brushes exert control, and others are more like mops, dragging along the paper and leaving a brushy mark that gives (or reveals) character. Just like the pointed brush holds shown above, there are several holds for the Chinese brush: holding the brush handle vertically, holding the brush handle at an angle, working with just the tip, and working with splayed bristles.

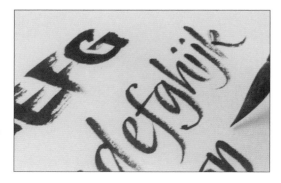

LOADING THE INSTRUMENTS

In fine writing, where precise control over the flow of ink is extremely important, use a paintbrush to load the pen with ink. To maximize consistency, load the ink with a medium-sized brush. If you dip a pen, first test it on a scrap of paper. In lettering, you must be able to predict what your tool will do—at least to some degree. Once you have established control, you can take more chances.

Some beginners have trouble judging ink dilution. If you dip and you load too much ink into the pen, you will end up with blobs. If you do not load enough ink, you will have to reload too frequently, which creates a break in rhythm. Practice is the key to fine tuning your loading skills.

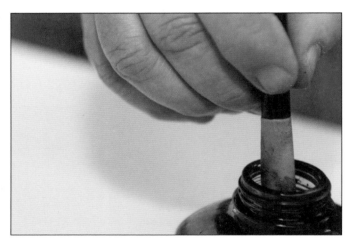

Dipping *For more spontaneous writing, you can get away with dipping the pen in the ink. Just be aware that the first stroke you make on the paper will release the most ink; subsequent strokes will release less ink.*

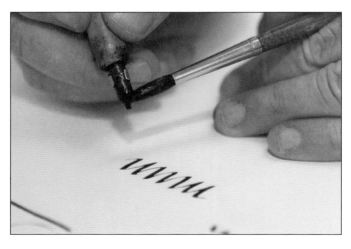

Using a Brush *Begin by taking the loaded brush in your dominant hand. If writing at a small size, carefully touch the tip of the pen with the brush and load a little ink into the reservoir. How much ink you load depends on how small the writing, how fine and absorbent the paper, and how fluid the pigment (ink).*

LOADING COLORED INK & PAINT

When working with color, you will dilute your ink or paint with water to varying degrees depending on the effect you want to achieve. Very controlled (fine) writing cannot be expected with loose, watery ink. An eyedropper is a handy tool for loading a pen when you want to create multicolored marks (see below). Any time you are diluting ink or paint and loading your writing instrument, consider the type of pen (or brush) you are using in relation to the size of the lettering, the density of the ink pigment, and the thickness and absorbency of the paper. Colored lettering is covered in more detail in Part II: Illuminated & Colored Lettering (page 71).

MAKING MULTICOLORED MARKS

You will need two jars of water: one with clean water for loading your pen and mixing paints and one for rinsing your pens. Start by dipping your pen in the clean water. Then use an eyedropper bottle to add a bit of diluted watercolor to one side of the pen; add another color to the other side of the pen. Then test your stroke.

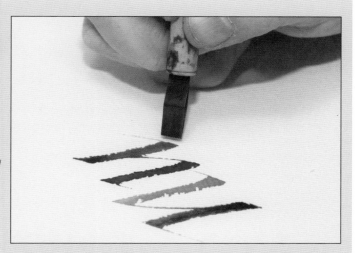

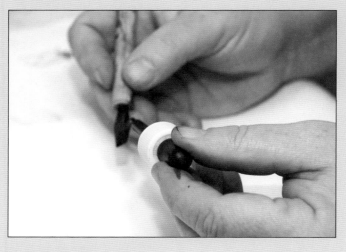

PARTS OF LETTERS

The diagram on the opposite page will familiarize you with the terms used throughout the book. Refer to this page when learning how to form each letter. As you can see, the various stroke curves and extensions of calligraphic lettering all have specific names. You'll also see the five basic guidelines (ascender line, descender line, waist line, base line, and cap line), which will help you place your strokes.

FORMING THE LETTERS

The term "ductus" refers to the direction and sequence of the strokes, which are indicated on the following pages with red arrows and numbers around the examples. Broad pen letters are formed with a series of separate strokes, so it's important to follow the recommended ductus while learning. However, with experience, you'll develop your own shortcuts to forming the letters.

TERMINOLOGY

The terms "uppercase" and "lowercase" come from the era of hand-set type, when individual metal letters were stored in shallow cases; therefore, these terms should not be used in calligraphy. It's better to use the terms "majuscules" (for uppercase letters) and "minuscules" (for lowercase letters). Also, avoid using the term "font," which generally refers to computer-generated letters. When referring to different hand-lettered alphabets, use the term "style" or "hand."

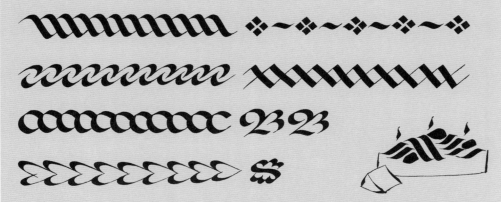

UNDERSTANDING THE BROAD PEN

Basic Shapes *Start by making simple marks as shown above, and keep the pen angle constant to create a sense of rhythm. Pull your strokes down or toward you; it is more difficult to push your strokes, and doing so may cause the ink to spray from the nib. Practice joining curved strokes at the thinnest part of the letter, placing your pen into the wet ink of the previous stroke to complete the shape. This is easiest when your pen angle is consistent.*

Decorative Marks *Medieval scribes often used the same pen for lettering as they used to decorate the line endings and margins of their texts. The broad pen can be used like any other drawing tool; practice drawing a variety of shapes to learn more about the pen's unique qualities. For instance, turn the paper to create the row of heart-shaped marks.*

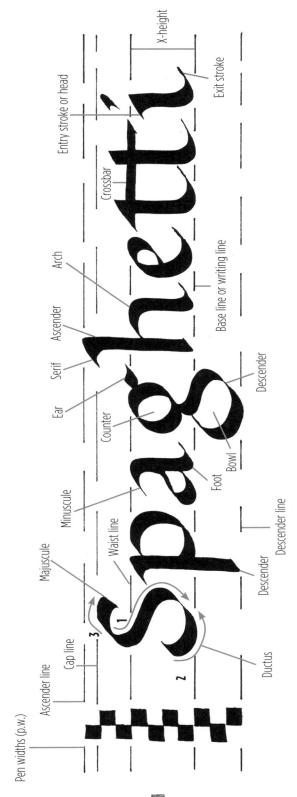

Pen widths (p.w.)

Ascender line

Cap line

Majuscule

Waist line

Minuscule

Entry stroke or head

X-height

Crossbar

Arch

Ascender

Base line or writing line

Serif

Ear

Counter

Descender

Exit stroke

Foot

Bowl

Ductus

Descender

Descender line

17

Skeleton

Mastering the skeleton hand gives you the basic skills for learning other hands. This hand features the basic underlying structure (or skeleton) of the letterforms. Practicing these letters will train your hand to remain steady while drawing straight and curved lines.

MINUSCULES

Learning the subtleties of the letter shapes will make the difference between creating plain-looking letters and beautiful ones. Notice that the "o" fills the entire width of a square (equal to 4 grid boxes by 4 grid boxes). Other round letters are about ⅞ the width of that square, and most of the other minuscules (except for the i) are ¾ the width of the square. Proportion and alignment, as well as consistency, all play a part in giving your writing a clean look and producing characters that are easy to read. As you can see, certain letters share common shapes. Practice the different styles using these letter families.

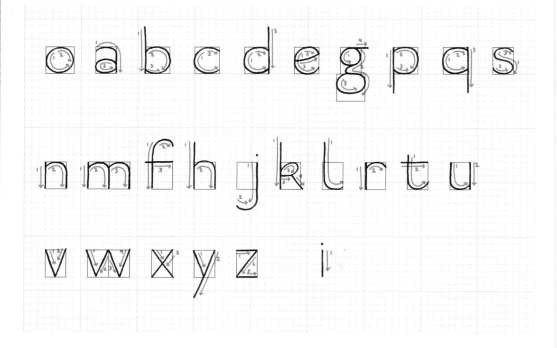

Form these letters using the drawing nib.

TIP

Use grid paper when learning to letter to help give you a sense of proportion.

PRACTICE HERE

MAJUSCULES

When drawing majuscules, understanding the correct proportions will allow you to consistently form handsome-looking letters. The shape of the "o" (the "mother" of every alphabet) determines the shape of almost all the other letters.

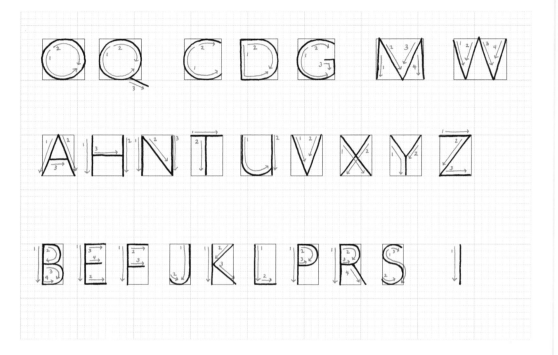

TIPS

- Test new nibs and papers before starting a final work to see how they respond to the paints or ink.
- You may need to adjust the thickness of the watercolor or gouache according to the angle of your work surface, or lay your paper on a less oblique angle to work.
- Keep your work area clean, and check your fingertips when handling finished work.
- Do not press down on your pen nib too hard; it will drag on the surface of the paper and may stick in one spot, causing a blot.
- Use a constant speed as you form your letters; this gives your work a rhythm and helps you make the letters more consistent.

PRACTICE HERE

Foundational

Begin your practice of broad pen lettering with the Foundational hand:
The letter shapes are simple, formed by very basic strokes, and most familiar to
your eye. It's a great choice for beginners and when legibility is important.

MINUSCULES

The minuscule letters are easier to master, so begin writing these out before
you start on the majuscules. Follow the ductus for each letter, and practice until
you are able to form straight up-and-down strokes and smooth, round shapes.

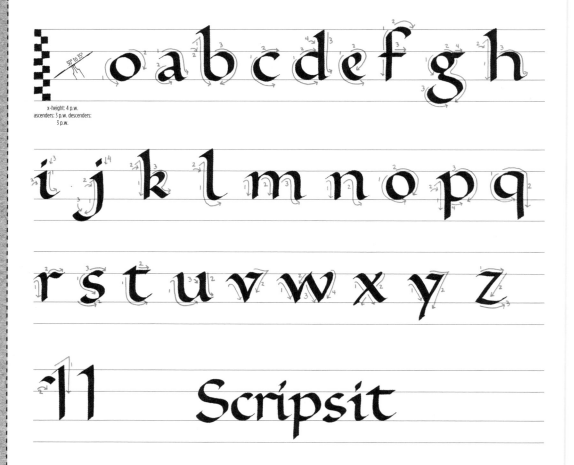

x-height: 4 p.w.
ascenders: 3 p.w. descenders:
3 p.w.

Scripsit

Form these letters using a #1 roundhand nib.

22

PRACTICE HERE

30° to 35°

x-height: 4 p.w.; ascenders: 3 p.w.; descenders: 3 p.w.

MAJUSCULES

Practice writing similar letter groupings: round letters, arched or half-round letters, and angled letters. Then write words that use both majuscules and minuscules to develop a sense of spacing and proportion when writing them in combination.

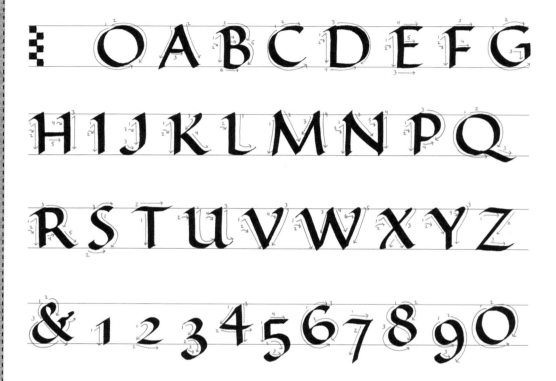

Form these letters using a #1 roundhand nib.

KEEPING VISUAL BALANCE

Majuscules should be a little shorter than the minuscule ascenders (in this case, six pen widths). To keep the majuscule and minuscule letters visually balanced, use a 25° to 30° pen angle (slightly flatter than on minuscules), which makes a broader stroke.

PRACTICE HERE

30° to 35°

x-height: 4 p.w.; ascenders: 3 p.w.; descenders: 3 p.w.

Uncial

One of the oldest hands, Uncial (pronounced "un-shul") is among the easiest to learn. This hand has elements of both majuscules and minuscules. As you work, keep the letter shapes wide and round. Ascenders and descenders are very short in keeping with this hand's essentially majuscule style.

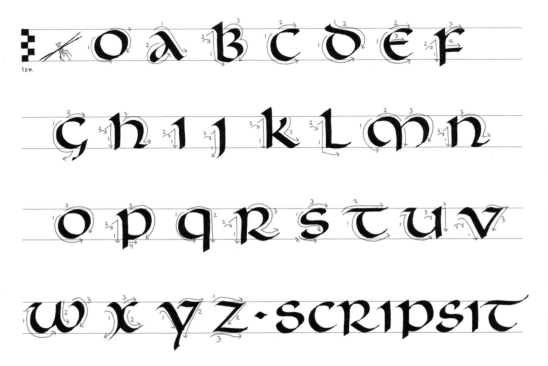

5 p.w.

Form these letters using a #1 roundhand nib.

SERIFS

Uncial serifs start with a wedge-shaped stroke. Begin with a 30° angle at the start of the stroke and move the nib up and to the right to create a thin line; then pull the nib straight down, toward you, forming the stem stroke of the letter. Fill in the small angle of the wedge with a short curved line.

5 p.w.

Runic Versals

Uncial does not have a set of majuscule letters, but you can use these runic letters in combination with Uncial letters. Runic letters were often used as versal letters, or decorative letters used at the beginning of a chapter or a verse. These are "drawn" letters and can be made using a pencil, a brush, or a narrow nib, as shown here, and are called "compound letters" because multiple strokes are used to make them.

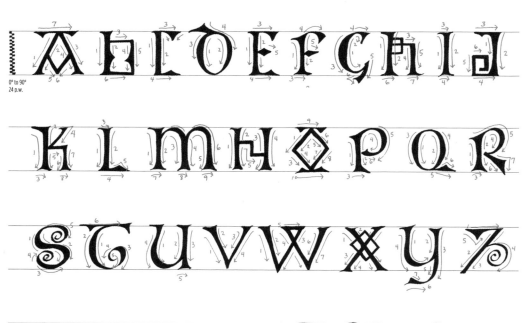

0° to 90°
24 p.w.

For boxes and swirls, add extra strokes as shown in the letter examples. To draw the triangular serifs, turn the broadhand nib and use the corner, as shown at left.

Form these letters using a #4 roundhand nib or a drawing nib.

CREATING LETTER STEMS

Double stroke the stem letters, leaving a small gap between each line. Then close the stems at the top and bottom with short, curved strokes. Complete by filling in the stem letters with ink, if desired, as shown in the letters above.

PRACTICE HERE

0 to 90°; 24 p.w.

Versals

These versatile letters are used in expressive calligraphic work; more modern-looking versals can be drawn without serifs. The versals below have been left unfilled to give you a better idea of their structure and how to reproduce them.

ROMAN

This style uses compound strokes. You'll notice that the vertical stem strokes curve in slightly at the center, and the two-stroke verticals and diagonals are about three pen-strokes wide. Draw the skeleton majuscules with a pencil first, keeping to classic proportions.

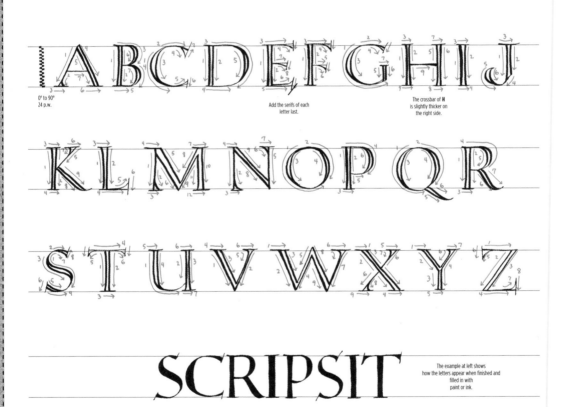

0° to 90°
24 p.w.

Add the serifs of each letter last.

The crossbar of H is slightly thicker on the right side.

The example at left shows how the letters appear when finished and filled in with paint or ink.

Form these letters using the drawing nib.

PRACTICE HERE

0 to 90°; 24 p.w.

LOMBARDIC

Lombardic letters are generously proportioned versals based on round Uncial forms. Use a smaller nib for refining the letters. In most cases, you will draw the interior strokes first and then build outward. This version has a greater contrast between thick and thin, making the letters more dramatic.

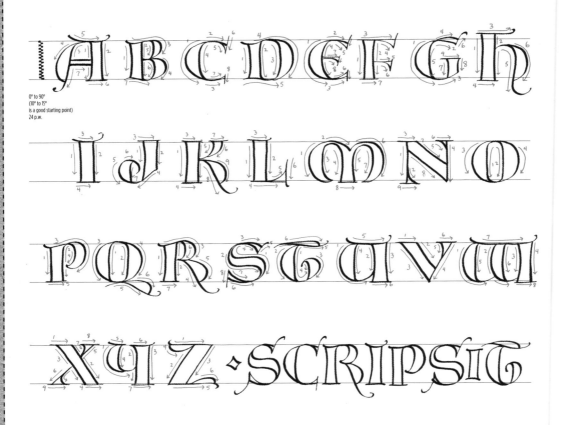

0° to 90°
(10° to 15°
is a good starting point)
24 p.w.

Form these letters using the drawing nib.

BALANCING SIDES

The curved and straight sides of a Lombardic letters, as seen in the U at right, are visually balanced—not measured to be an identical width. Note how the widest part of the curved side is actually much wider than the straight, upright stroke.

PRACTICE HERE

0 to 90° (10 to 15° is a good starting point); 24 p.w.

Italic

The quickly written Italic hand was developed from
humanist bookhand, letterforms from the Italian Renaissance.
Based on 10th-century minuscules, this style often was used
to produce books prior to the invention of the printing press.

MINUSCULES

These letters are slim, graceful, and rhythmic. They relate strongly
to the handwriting of today, so they should feel very natural for you to form.
Each letter leans forward at a 5° to 10° angle to the writing line;
this is known as "letter slope."

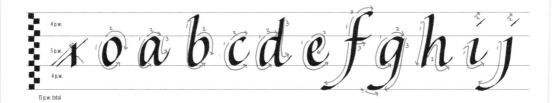

Form these letters using a #2 1/2 italic nib.

TIP

As you move the pen to form each letter, keep the tip of the nib at the same angle through the entire
stroke. To do this, keep your wrist steady, moving the pen by moving your arm, not your hand. Italic
needs extra interlinear space so the ascenders and descenders don't tangle.

PRACTICE HERE

4 p.w.

5 p.w. 40 to 45°

4 p.w.

MAJUSCULES

Italic majuscules feature swashes, which are rounded extensions that flow from the basic form of the letter. Avoid writing an entire word in swashed letters; it will look too busy. When writing whole words and lines, these majuscules can be made without the swashes for a clearer, more readable appearance. Remember: A little goes a long way when adding flourishes to your letters.

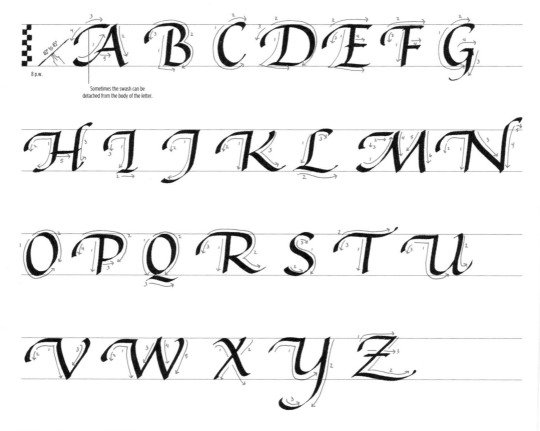

Sometimes the swash can be detached from the body of the letter.

Form these letters using a #2 1/2 italic nib.

DRAWING SWASHES

The swashes on italic majuscules are very generous in width, doubling the width of the entire letter in many instances. Use these large swashes to emphasize words or to begin a page.

PRACTICE HERE

40 to 45°

8 p.w.

Blackletter

TEXTURA QUADRATA

The common characteristic of all blackletter hands is the compression of letters and spaces, which allows more words to fit onto a page. This bold style also features a dynamic contrast of fine hairlines with heavy letters. The blackletter style shown below is called "Textura Quadrata," or "broken letters," and it often resembles a picket fence.

MINUSCULES

Blackletter hands, also called "Gothic script," are closely packed in appearance; the letters have very little interlinear space, and the ascenders and descenders of the minuscules are short (ranging from 1½ to 2 p.w.). It gives the page a dark appearance overall.

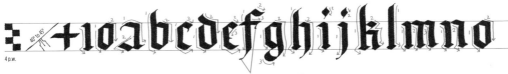

4 p.w.

The letter f features two distinct hairlines. To create a hairline,
lift your nib onto the leading corner and drag the ink.

Form these letters using a #1 roundhand nib.

38

PRACTICE HERE

4 p.w.

BATARDE

"Batarde" is a cursive blackletter hand that was the primary bookhand used in the late Middle Ages.

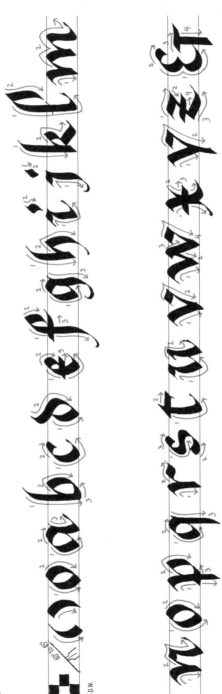

Form these letters using a #1 roundhand nib.

PRACTICE HERE

3 p.w.

MAJUSCULES

Contrast curvy, wide majuscules with the closely packed minuscules. These letters can be used with either style of minuscule on the facing page. Study old manuscripts for examples of the many different styles of Gothic majuscules, or create your own variations.

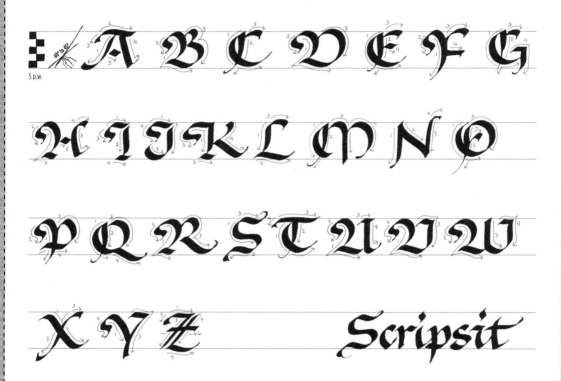

Form these letters using a #1 roundhand nib.

TIP

Use these majuscules for emphasis. Words created with all blackletter majuscules are awkward and illegible.

PRACTICE HERE

5 p.w.

Contemporary Calligraphic Styles

Classical lettering is refined and beautiful, and its letters have withstood the test of time. One of the most celebrated examples of this style can be found at the base of Trajan's Column in Rome. The Trajan Inscription contains the most elegant forms of Roman lettering, and it was written nearly 2,000 years ago. Imagine that: We still use the letters of the Roman Empire! They are considered the highest in the letterform pyramid and are a fine balance of form and function. They are (unfortunately) also difficult to replicate. In this section are some variations that are not as difficult. They are done with a broad-edged brush or pen.

TOOLBOX

- Broad-edged brush
- Broad-edged pen
- Pointed pen
- Ruling pen

ZENFUL

This adaptation is an elegant and less difficult version of the Roman Imperial Capitals. Zenful is a narrow Roman alphabet without serifs and with highly modular shapes in its curves and a soft triangular motif. This alphabet has strong links to classic function and form.

ABCDEFG
HIJKLMN
OPQRSTU
VWXYZ &

LUX ET UMBRA VICISSIM
SED SEMPER AMOR

"Light and shadow by turns, but always love."

45

LATINA

Latina letters are playful as they bounce on the baseline, yet they contain the elegant lines of Roman capitals—delicate and airy.

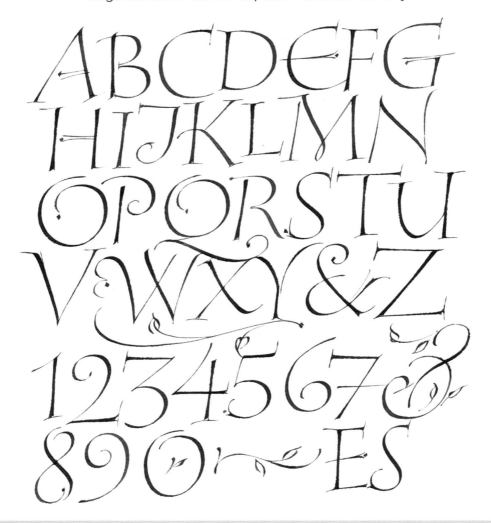

A LESS STRENUOUS METHOD

This Latin phrase was written with a pointed pen modified by shaping the point to a small, broad edge with an Arkansas stone. This helped the pen to function as both a pointed pen (flexible width) and broad pen.

PARVIS IMBUTUS
TENTABIS GRANDIA TUTUS

"When you are steeped in little things, you shall safely attempt great things."

LIBRETTO

Libretto is a flowing script with strong calligraphic leanings. Start by practicing the straight and curved lines that form this alphabet. Then move on to O, G, C, and Q. Once you've mastered those letters, move to B, R, and P, and then move on to the rest of the alphabet. You should warm up with families of letters rather than start with A and work your way to Z. You want to feel the strokes by repeating them.

ABCDEF
GHIJKLM
NOPQRST
UVWXYZ
abcdefghijk
lmnopqrstuv
wxyz Piano

PRACTICE HERE

Brushstroke

Brushstroke letters show changes in transparency with the animated stroke. The brush is popular for its versatility and because it is an expressive tool. One can usually see where the stroke started, its speed and direction, and where it ended.

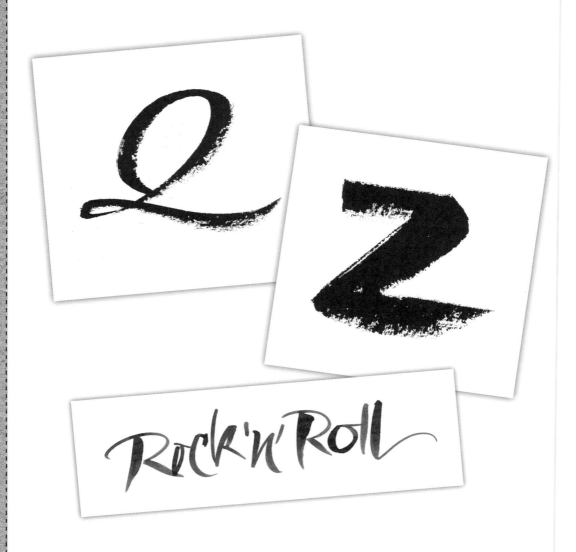

ANIME

Written with ink and water to achieve a variety of tones, Anime is basically narrow and medium weight, with the occasional wider letter and heavier-weight stroke. If you are consistent with the basic rhythm, these two variations will go a long way to giving the feeling of variety. Pressure and release in rapid movement is necessary to create variations in each stroke.

abcdefghij
klmnopqrs
tuvwxyz

ABCDEFGH
IJKLMNOPQ
RSTUVWXYZ
Euro Rock'n'Roll

BEIJING

Use a larger brush for this style. The basic strokes are as follows: press, move, stop, and then lift to make a bonelike stroke. You can press and move while lifting slightly to produce a stroke that tapers off. It will take some practice to feel free in your movements, but this type of brush makes very characteristic marks, so it should be fun. In this alphabet, the side of the brush is used more than the tip, occasionally "squashing" the hair when the ink is running out to create rough drybrush marks.

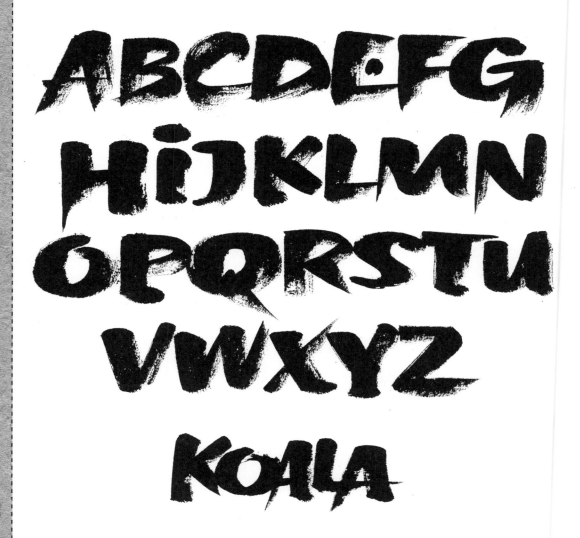

FRESH

Any pointed brush should work for this alphabet, but remember that every brush produces a different result. Write these letters quickly, keeping in mind that rhythm and energy are the important factors in this style. The strokes are a mix of the side and point of the brush, so practice several holds and stroke variations to learn what works for you.

abcdefghijklmn
opqrstuvwxyz

ABCDEF
GHIJKLMNO
PORSTUV
WXYZ

Bravo

PRACTICE HERE

Fun & Funky

You can use these styles in place of typography, where it complements a digital rendering with a human element. Once you get the hang of the basic rhythm, you can invent your own alphabet. You do not need every letter to be crazy or different. In order for the variety to work, you must establish some order or unity to the letters.

TOOLBOX
- Broad-edged pen
- Pointed pen
- Modified pointed pen
- Ruling pen
- Folded ruling pen

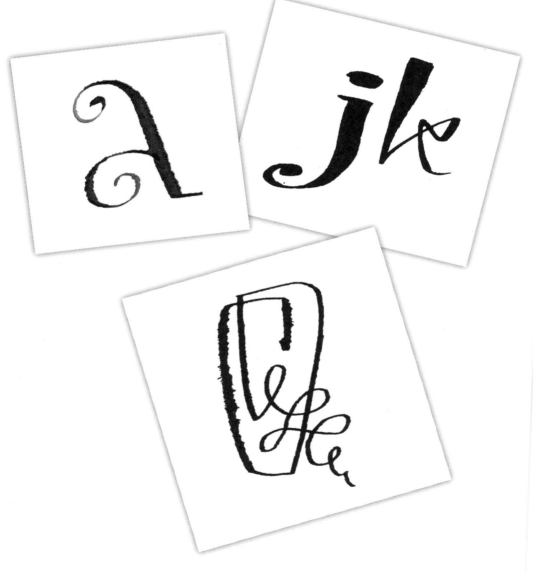

FUNK 49

This stroke has a taper, and the weight feels a bit random. Despite this, notice that it still has a nice movement and rhythm. Using the side and tip of a ruling pen are the two basic moves you will employ. The advantage of the ruling pen is that it does not create fixed-width lines, thereby allowing you to create interesting shapes. Unfortunately, this "advantage" is also the downside, as you need to learn to control the pen before finding consistency.

ABCDEFG
HIJKLMN
OPQRSTU
VWXYZ&

abcdeffg
hijklmno
pqrstuv
vwxyyez
Super

SATURNIA

This is a mix-and-match alphabet hung on a structure of square-shaped, narrow letterforms, with the occasional wide letter.

abcdefghijk

lmnopqrstu

vwxyz æs 123

4567890 ABCD

EFGHIJKLMNO

PQRSTUVWXYZ

& Taxi

POLYLINE PILE-UP

Polyline Pile-Up, which pairs a doodlelike quality with sophisticated play, is a good match for the ruling pen. Characterized by lots of movement and personality, these letters can also be created with a pointed pen or pencil. As in any other alphabet, one must grasp the idea of dynamic balance (the amount of black versus white that each letter contains) with a touch of variation. The lines dance around the narrow, squarelike structure that makes up each majuscule.

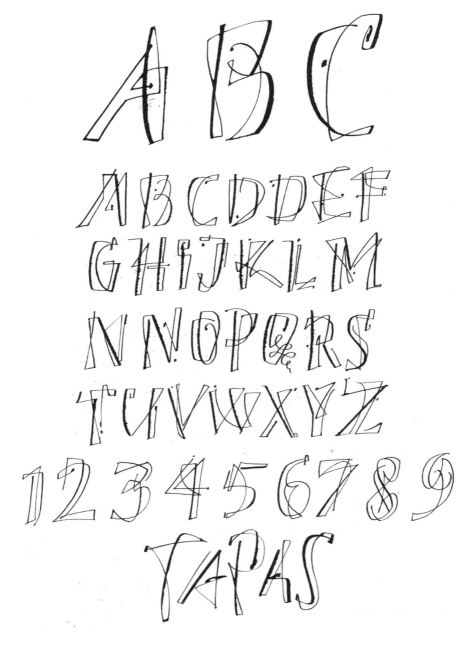

PRACTICE HERE

Quirky & Curlicue

When drawing the alphabets in this section, think of both your audience and of what "voice" you imagine is behind the letters. Once you determine this, you can add or take away details to suit your tastes, and you will know that your work is communicating the tone that you intended. You can create even letters that stand alone as purely decorative works of art.

TOOLBOX

• Pointed brush
• Pointed pen
• Ruling pen

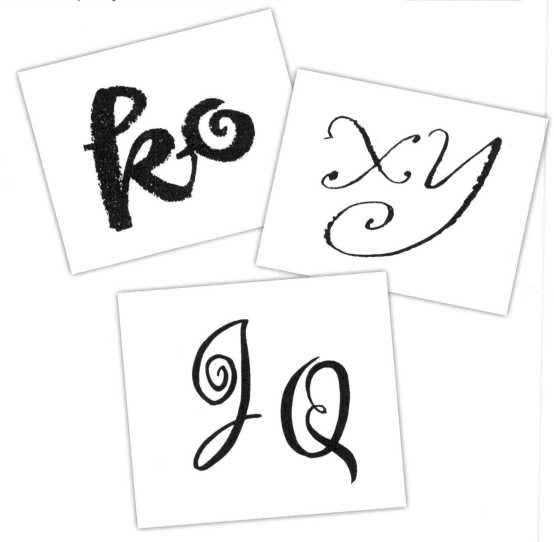

BOING! REGULAR

This alphabet can go in several different directions, depending on attitude. It can be busy and quirky, or the lines can be smooth or broken. The letterforms are on the narrow side to allow for the curlicues that encroach on their neighboring letters.

A B C D E F G H I

J K L M N O P Q R

S T U V W X Y Z

a b c d e f g h i i j k l

m n o p q r s t u v w

x y z Anna

BOING! HEAVY

This version of the Boing! alphabet displays curlicue details and slightly broken curves, but it is bold and should be written with a pointed brush. You can create these letters in a painterly style, which will emit a look that is both fun and decorative. Your brush technique may vary depending on what paper you use, but you will employ the side and tip. Learn to differentiate between the character, the basic structure, and the details that can be changed.

abcdefgh
ijklmno
pqrstuv
wxyz AB
CDEFGHI
JKLMNOPQRSTUV
WXYZ 1234567890

Cocktail

TING!

This alphabet can be created using a ruling pen or a pointed pen. Its main features include curlicues, lots of bounce, and the strategic placement of dots at the end of strokes.

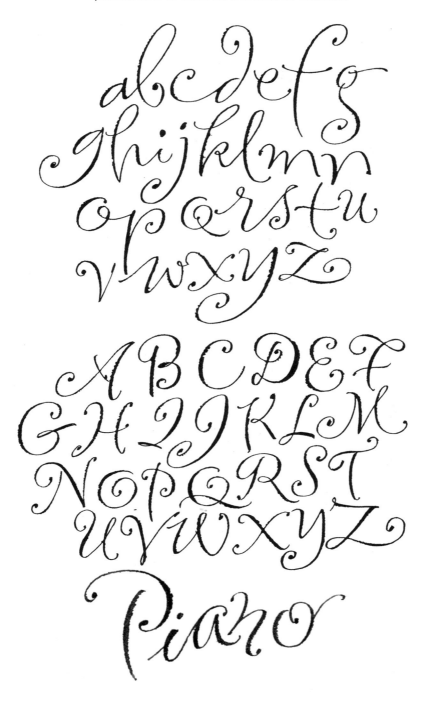

PRACTICE HERE

NUMERALS

Here are various styles of numerals that pair well with most contemporary letter styles. It is not necessary to use the same form as the rest of your message. A distinctive numerical style can add interest to your piece.

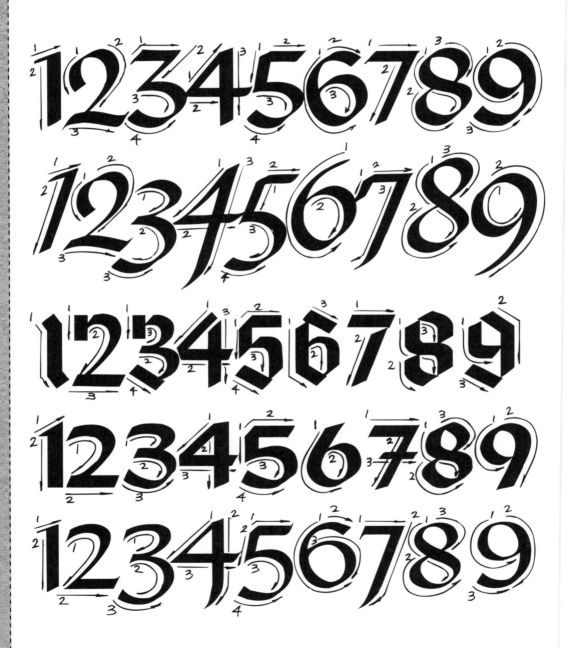

123456789

123456789

123456789

123456789

123456789

PRACTICE HERE

PART II

Illuminated & Colored Lettering

TOOLS & MATERIALS

ILLUMINATION SUPPLIES

Gouache

Gouache (pronounced "gwash") is similar to watercolor paint, but it contains more filler, which makes it opaque. It can be thinned to a consistency suitable for flowing from a nib. You can use the primary colors (red, yellow, and blue) alone, or you can mix them together to create almost any other color. Use gold gouache to add gilded accents that mimic the brilliance of gold leafing.

Paintbrushes

A large round paintbrush is perfect for mixing your colors, loading or filling the pen, and painting large areas. A small round brush is useful for painting fine details. Round paintbrushes have tips that taper to a point—this shape allows the bristles to hold a good amount of moisture while maintaining the ability to produce fine lines. Before you paint, be sure to dampen your brush so that the ink or paint slides off the bristles easily.

Palette

A white ceramic palette with several wells will be handy when you mix colors. The wells allow you to keep an array of thinned and mixed colors handy and prevent the colors from running together. A palette with a large center well provides a convenient place to hold clean water for adding to mixes in other wells.

DRAWING SUPPLIES

Pencils

You will need pencils of varying hardness, indicated by grades (a letter and usually a number). H pencils have hard leads—the higher the number, the greater the hardness. These pencils are best for producing fine, light lines, but be aware of the amount of pressure you apply; it's easy to score the paper. B pencils have softer leads—the higher the number, the greater the softness. These pencils produce darker lines with less pressure. HB pencils are midway between hard and soft grades and are great for general purpose drawing. Use a carpenter's pencil to practice drawing very thick and thin strokes.

Other Supplies

A drawing board, T-square, and triangle with a 90° corner will make ruling guidelines fast and easy. If you don't have a T-square, a cork-backed metal ruler will work. The following items also are useful: tracing paper for transferring letters and designs, a white vinyl eraser, low-tack or artist's tape, a jar of water, a large flat paintbrush, and a soft rag for wiping nibs. Paper towels also are helpful for keeping your work area clean and wiping your hands to avoid smudges on your work. Keep a pad of damp paper towels in a flat dish near your work, so you can wipe your fingers often to avoid transferring the inevitable ink smudges to your calligraphy; an alternative that works wonders on ink and paint is plain baby wipes.

Lettering in Color

Lettering with gouache allows you to use your pen to paint with words. While this technique requires a bit of preparation to achieve the right consistency to flow from the pen, the effort is worth the reward of seeing your calligraphy come to life in brilliant color.

1 Squeeze a pea-sized amount of gouache on the palette. Add distilled water one drop at a time and mix with the large brush until it is the consistency of cream. (Distilled water doesn't contain minerals that can affect the pigment.)

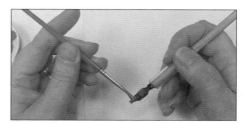

2 Now load the large brush with the mix, and drag the brush across the side of the nib (over the gap between the nib and reservoir). If you decide not to use a reservoir, simply drag the brush across the bottom of the nib.

3 Practice making a few strokes and forming a few letters. Adjust the thickness of the gouache as needed to get it to flow evenly from the nib. It should be thicker than ink.

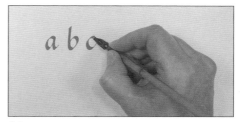

4 Write a few more letters, and you'll begin to understand how to control the flow of the paint with consistent speed and proper pressure.

TIPS FOR USING GOUACHE

- Use distilled water to thin gouache for lettering.

- The bigger the pen nib, the thinner the paint needs to be. Small nibs require thicker ink or gouache.

- A new tube of gouache has a few drops of glycerin at the top to keep the paint moist. Squeeze out the glycerin and discard before using the paint.

- Mixed gouache may thicken on the palette as you work; thin it as needed with drops of distilled water.

- Clean the nib often by dipping only the tip in water and wiping it dry.

- Wipe all the moisture off the nib before putting your tools away.

- When painting highlights and other details, dip just the tip of the brush into the paint and wipe off any excess on the edge of the palette cup.

- Periodically stir the paint to maintain an even distribution of the water in the paint.

- Work on a flat surface to keep paint from pooling at the bottoms of the letters. Dried gouache can be reconstituted with water, but some colors may not reconstitute easily.

Illuminated Letters

As your calligraphic skills develop, you may enjoy adapting and inventing decorative techniques to use with your letters. Look to both ancient and modern illumination for inspiration. The resulting letters can serve as stand-alone monograms or as versals to begin a page of beautiful, handwritten text using your newly developed skills.

DIAMOND BACKGROUND DESIGN

1 Letter a majuscule with gouache using a wide nib.

2 Use a pencil to draw a diagonal grid pattern in the counters.

3 Paint alternating squares of gold and another bright color, such as blue.

4 Add a fine outline around the letter and a decorative border that echoes the shapes of the triangles and squares.

FILIGREE DESIGN

1 Draw and paint a Lombardic versal. Blue is the traditional color for this style.

2 Use pencil to draw a filigree design around the letter. This is simply advanced doodling, so there is no wrong way to do it.

3 Use a drawing nib to trace over the filigree design with red paint, also the traditional color for this style. The center design is a series of comma shapes placed in a radial design.

4 When drawing the filigree, keep your lines fluid and graceful. You will probably not follow the pencil sketch exactly, and, with a little practice, you won't even need guidelines.

SPLIT-NIB EFFECT WITH BLACK AND GOLD

1 Use a #1 roundhand nib and black ink to write Gothic majuscules. You won't want to use a smaller nib than this; the lines have to be thick enough so that you can stroke within them using the small paintbrush.

2 When dry, use a small brush to add a center line of gold gouache, which creates a split-nib effect. You may need to go over the gold line two or three times to make it opaque. You also can touch up the black ink as needed.

CREATING DECORATIVE BORDERS

Part of the excitement of illumination comes from the creativity you express by adding elements to enhance your calligraphy. Decorative details need not be limited to letterforms. You can add borders, frames, and other colorful accents to your pages, as well as small flower and leaf shapes and geometric forms.

To begin your borders, draw the outlines, leaves, and shapes using the drawing nib and thinned ink. After the ink dries, use thinned gouache to paint the designs, so the lines show through. If you use white gouache, you may want to touch up the outlines. Use the small brush and gouache—not ink—to touch up lines on top of painted areas.

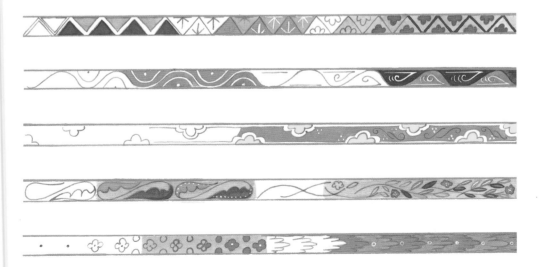

Illuminated Ancient Runic Style

The word "illumination" comes from the Latin word *illuminare*, which means "to light up or enlighten." In calligraphy and book arts, it refers to decorating a page with bright colors and shimmery gold. Decorated majuscules and intricate borders lit up the pages of ancient books and offered an exciting way to provide colorful focal points alongside black lettering.

1 Rule two parallel lines one to two inches apart on art paper. As a shortcut, you can draw lines along both edges of a ruler.

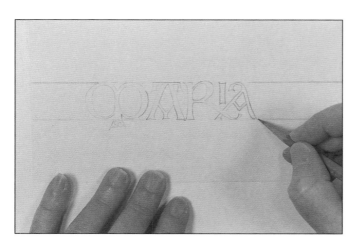

2 Use a pencil to lightly draw a word or name between the two parallel lines. In this case, the name is "Maria."

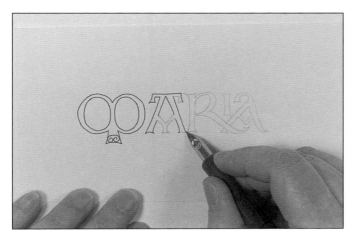

3 Use a drawing nib; a narrow, flat nib; or a small brush to outline the letters with ink. Let the ink dry, and carefully erase the pencil outlines.

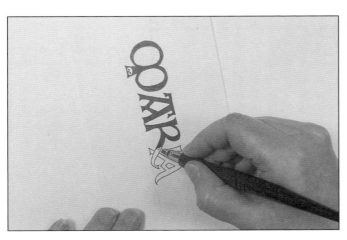

4 Use a thick nib or small brush to fill in the letters with ink, carefully moving your tool within the outlines.

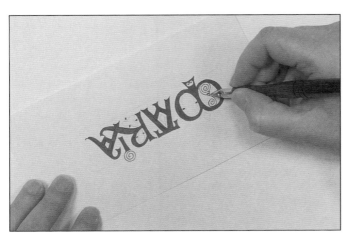

5 Draw designs in the counter shapes and add some decorative spirals. The spiral used in the left counter of the M is a simple S shape with a fuller bottom. Draw a border around all the letters, and ink in the spirals.

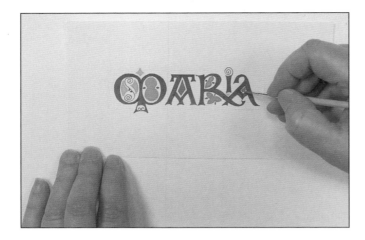

6 Prepare several intense mixes of gouache paint. As you work across the word and fill in the counters with shapes, alternate your paint colors.

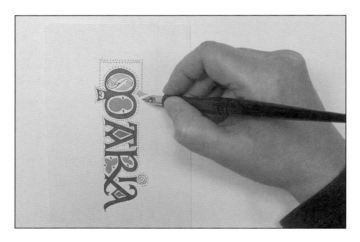

7 Use red gouache in a drawing nib to apply rows of red dots around the letters and the borders of the panel. Try to space your dots evenly, but don't worry if your dots don't exactly line up—this imperfection will give your work a natural, organic quality.

TIPS FOR ILLUMINATION

- A bright red accent adds a bit of magic to the page. Medieval illumination artists often used red when decorating versals.

- Don't abandon your lettering practice once you start illuminating. Good calligraphy skills are essential to quality illumination.

- The sequence in which you work is important. The traditional order is to do the lettering first, then the gilding, and the color painting last. Gold paint may be applied at the same time as the colors, but always do

the lettering first. It's easier to hide mistakes in the borders than within the calligraphy.

- When working with color, keep your paintbrushes clean, so you don't muddy your artwork. Use two water jars for consecutive rinsing, and change the water in them often.

- If possible, use separate brushes for different colors—particularly light and dark shades.

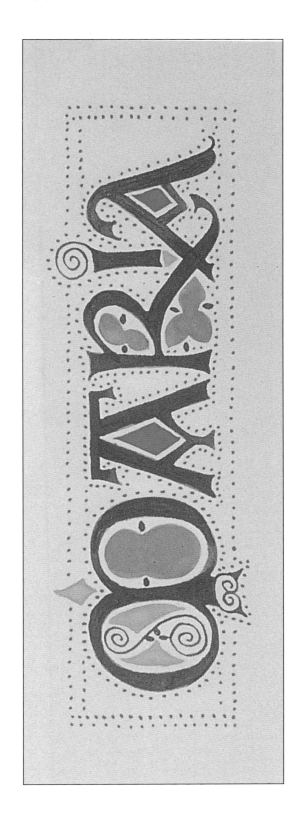

Illuminated Gothic Letter

Book illumination rose to the height of intricacy and beauty during the Medieval era. Artists often applied gold leaf to letters or to the backgrounds of versals and illustrations, which would catch the light as the page turned. Today, gold paint offers a similar effect that artists can use to create historically inspired Gothic letters.

TRANSFERRING THE DESIGN

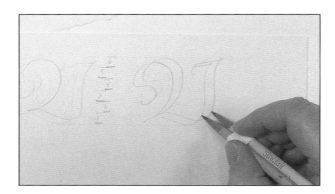

1 Tape two pencils together to create a tool for drawing large, unfilled letters. Make a pen-width scale by using the width of the pencil tips. To achieve a desired width, adjust the angle of the pencil points to an imaginary horizontal base line. Then outline your Gothic letter.

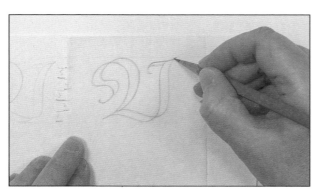

2 Tape tracing paper over the original letter, and trace it with an HB pencil, keeping the lines fluid. Draw the curves toward your drawing hand for a more natural line. Then turn over the traced letter and apply a thin layer of graphite over the back of the letter with a soft B pencil.

3 Now position the traced letter on the final art paper, graphite side down. Align the letter within the border of your paper using a triangle and a T-square. Then retrace the letter using an H pencil. The graphite on the back of the tracing paper will transfer the letter onto your paper.

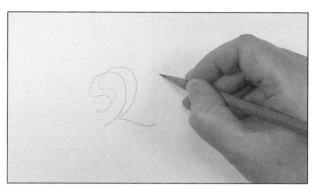

4 Remove the sheet of tracing paper to reveal the letter on your art paper. Then use a pencil to touch up the lines, as they may not transfer perfectly. Clean up any smudges with an eraser. Once you're happy with your final letter, you can add the decorative background around it.

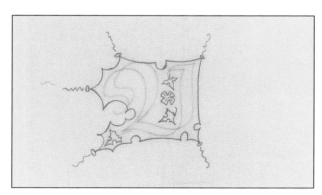

5 On a tracing paper overlay, draw the decorative shape around the V. Keep the lines close to the letter, creating a roughly square shape with medieval spikes. Add a few ivy leaves and a flower to fill spaces. On the left side, away from where the additional letters will be, let the spikes flare out.

6 Turn the tracing paper over and use the side of a soft B pencil to apply a layer of graphite over the leaves, flower, and border. Follow the procedures you used in steps 2, 3, and 4 to transfer this background to your art paper.

ILLUMINATING THE LETTER

7 Use a drawing nib and thinned ink to outline the letter, leaves, and flower. Keep the line weights consistent throughout the drawing.

8 Prepare dark green, light green, dark pink, golden yellow, blue, and gold in a mixing palette. Use a very small brush to carefully paint the letter, leaves, and flower. For tight corners, pull the brush toward the corner, lifting the bristles off the paper as you approach the corner to achieve a sharp point.

9 To get opaque coverage, first paint the area with thinned gouache; then flood it with thicker paint. Complete an entire area before moving to the next part of the letter. Gouache creates hard edges when it dries, so painting one area at a time keeps your strokes smooth.

10 Use gold paint to fill in the background. The gold needs to be fairly thick to cover the area well, but thin enough so you can tease it into corners with the tip of the brush. Add some squiggles at the corners with black ink.

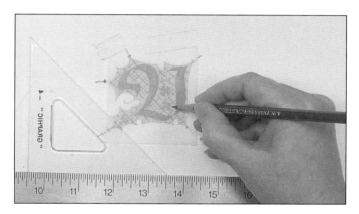

11 After the paint dries, place two layers of paper towel beneath your art paper. Place tracing paper over the letter, and use a straightedge and a sharp pencil to impress criss-crossing diagonal lines across the gold for a debossed look.

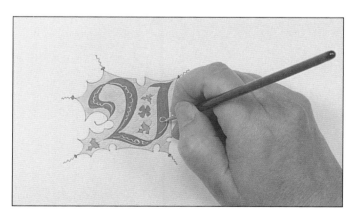

12 Use a small brush to paint white highlights on the letter, leaves, and flower. The white paint needs to be thicker than the mixture used for filling (such as the green), but thin enough to flow easily from the brush.

PAINTING THE MEDIEVAL BORDER

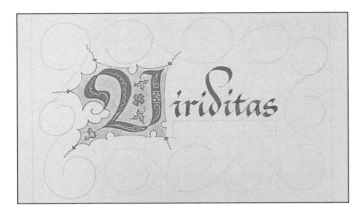

13 Use black ink to letter the rest of the word in a Batarde hand. Draw a border around the letters, and add the design under the word. Draw circles within the border. Add stems following the circles, alternating the direction of the vine around each circle.

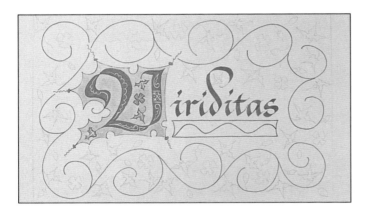

14 Use a drawing nib to ink the outline of the vine. Allow this to dry, and erase any pencil lines. Outline the small design beneath the bulk of the word, and add a wavy line across its center. Then draw some ivy and other elements with a pencil.

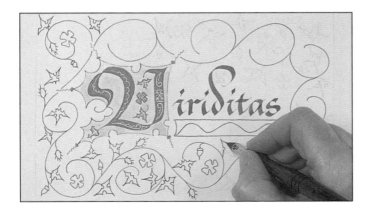

15 Now go over the leaves, stems, and flowers using a drawing nib filled with thin ink. Keep your lines fine and consistent, so there aren't any gaps, wide lines, or dark spots to distract the eye.

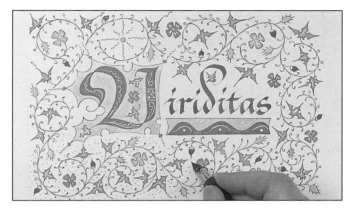

16 Use a small brush to paint the leaves and flowers. Fill in the small border using the same colors as the V. Use a drawing nib to add buds on the stem lines in the outer border, keeping them within the rectangular shape.

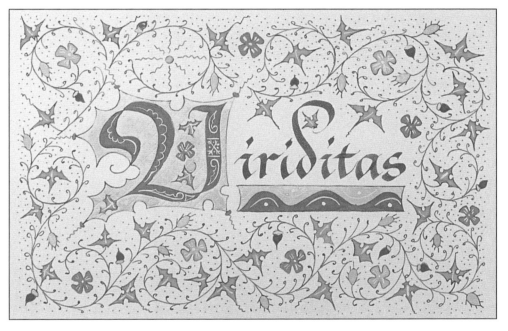

TIPS FOR CREATING A DECORATIVE BORDER

- Remember to draw the curves of the vines toward your hand for a more natural line. This motion applies to calligraphy as well; in most cases, you will pull each stroke down and to the right, turning the paper as needed.

- Keep your gouache washes fresh on your palette by stirring them frequently with a clean, moist paintbrush. Then you can switch between colors spontaneously while painting the flowers and leaves.

- To add texture and interest to your border, contrast the thin, curving lines with small dots using a drawing nib. Called "stippling," this technique also can be performed using the tip of a round paintbrush.

Backgrounds & Flourishes

Scribes today still use decorated letters to call attention to a special word or name. Letters based on classic, calligraphic design principles can be combined with more contemporary styles of painted backgrounds created to surround them. The result is an airier, more light-hearted look than the more traditional, rigid letter styling.

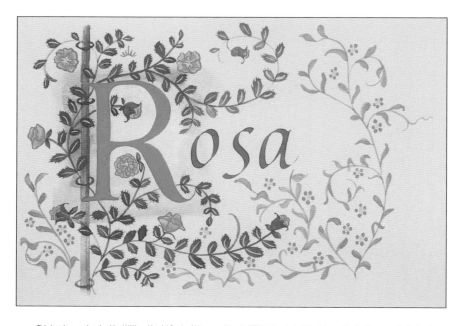

This border was inspired by William Morris' Book of Verse, written in 1870 at the start of the Arts and Crafts Movement in England.

WET-INTO-WET PAINTING

- To paint wet-into-wet, dampen the paper with a wet brush and then apply diluted color to the damp paper, as shown in steps 1, 2, and 3. The resulting colors flow and blend into one another, creating new colors where they meet.

- Tape the edges of your paper onto your work surface to prevent the paper from buckling as it dries.

- The heavier the paper, the less it will buckle. Always test your paper before starting.

- Experiment with color combinations on a piece of scrap paper first.

- This wet technique may take a couple of hours to thoroughly dry; don't move your paper while it's still wet, or the pooled color may run.

- The results of this technique may not be what you are expecting, but be open to surprises. The coloring that emerges when the background dries may help you decide which letter you will want to paint onto it.

PAINTING THE BACKGROUND

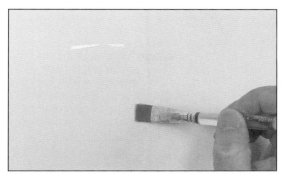

1 Lightly draw an outline for the background square. Prepare thinned yellow, red, and green gouache paint for the washes. Use a large brush dipped in clean water to loosely apply a square of water within the border.

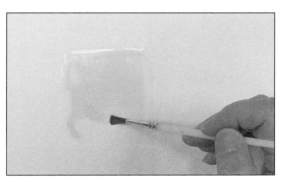

2 Load the brush with the lightest color. Touch the brush to the wet paper to apply a little color at a time. Keep the yellow at the center, as shown; then you can frame the yellow by dabbing and dragging the red around it.

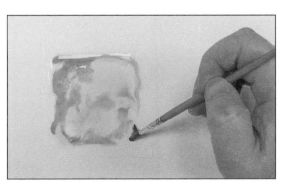

3 After adding the red, drop green into the edges. This will define the brush shapes you used to paint the square. If you like, "float" a brush full of thinned gold gouache into the wet paint. The gold gives a subtle shine to the background when it dries.

4 You may need to remove some of the extra water as you work. Take a piece of paper towel, and roll it into a thin pencil shape. Touch it to the most puddled water to draw up the excess, being careful not to absorb too much pigment in the process.

ADDING THE VERSAL

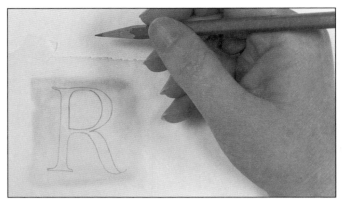

5 When the paint is completely dry, place a sheet of tracing paper over the painted square. Pencil the letter onto tracing paper and center it within the square, leaving a margin on all sides. Draw light marks on your art paper at the corners of the tracing paper, so you can replace it easily.

6 Turn the tracing paper over and use a soft B pencil to draw over the letter. Use an H pencil to transfer the letter to the painted square. Touch up the resulting pencil lines as needed.

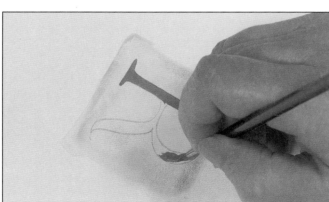

7 Mix dark pink by adding a small amount of white to red. Use a small brush to paint the letter. Load plenty of paint on the brush and keep a steady hand as you pull the brush toward you.

8 Clean up any rough edges of the letter by smoothing them with a layer of slightly thinner paint. Allow the letter to dry.

COMPLETING THE NAME AND FLORAL BORDER

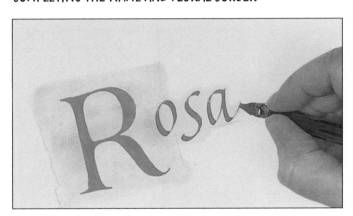

9 Rule the paper, positioning the baseline of the minuscules near the center of the large versal. This style of using an upright majuscule with an italic minuscule is a classic Renaissance combination. Load a #2½ italic nib with deep green gouache to letter the rest of the word.

10 Use a pencil to lightly draw the vines of the border on tracing paper. Add leaves, roses, and forget-me-nots. Transfer the vines, large leaves, and flowers. Draw the remaining smaller leaves freehand.

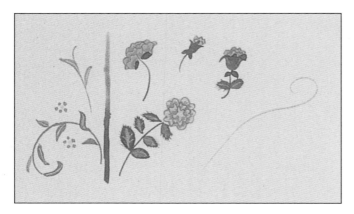

11 Mix medium and light pink; brown; blue-green and yellow-green; plus a few lighter and darker tints and shades of each. Test the colors on scrap paper. Use strips of paper to mask off the area not being painted on your art paper.

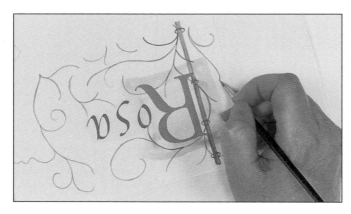

12 Use a drawing nib or a small brush to paint the vines, keeping the lines sinuous, even if it means straying from the pencil lines. Use thinned brown to paint the pole, and use thicker brown to paint the rose stems.

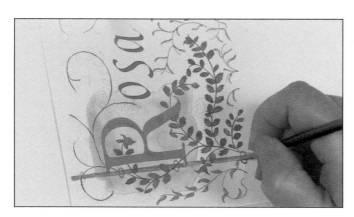

13 Use dark green to paint the rose leaves, giving the upper edges a serrated look. Paint the leaves of the forget-me-nots using two shades of yellow-green for added dimension.

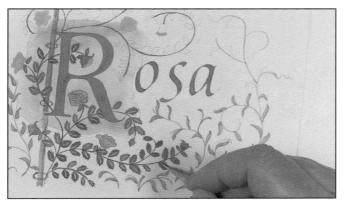

14 Use light pink to paint the shapes of the roses; then paint the edges of the petals with dark pink and shade the bottoms of the petals with medium pink. With a light tint of green, paint thin center lines on the rose leaves.

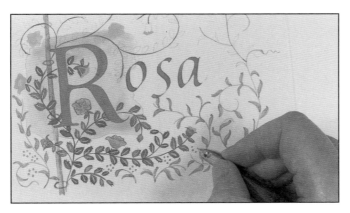

15 Use a small brush or drawing nib to add light blue forget-me-nots throughout the foliage. Add small yellow dots to the centers of the flowers.

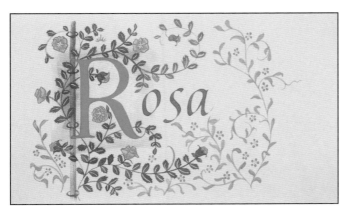

16 When the paint has dried thoroughly, erase any visible pencil lines.

Chromatic

When choosing colors to implement in your lettering art, keep in mind the basics of color theory, as well as the tone of the message you are trying to convey.

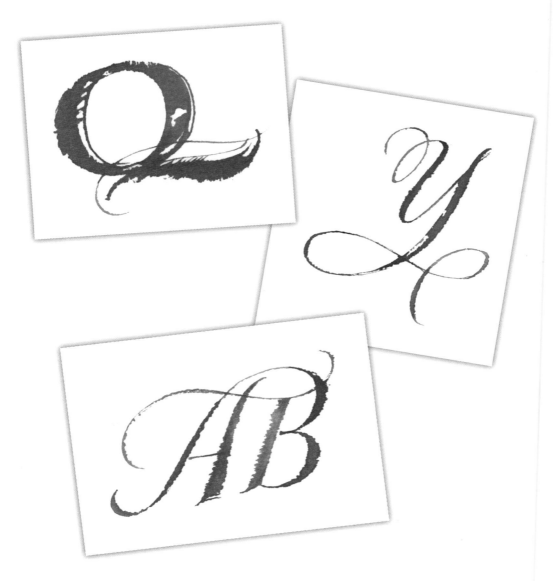

CHEER

Cheer was created with a folded ruling pen on rough watercolor paper. This alphabet resembles 19th-century scripts but involves taller minuscules. You can experiment with the height ratio of the majuscules and minuscules, but avoid making the minuscules exactly half the size of the majuscules. Elaborate with ascenders, descenders, and the last strokes of a word or group of words. Dynamic balance is full of tension, resulting in more interest.

KALEIDOSCOPE

Kaleidoscope is a mix of block and cursive letters. It appears to have more components because the block letters are different weights and sizes. As you add color, keep in mind the amount of light and dark, which should balance out for the overall desired look. Otherwise, this alphabet can look too busy. Think 70 percent bold and 30 percent light—never 50–50.

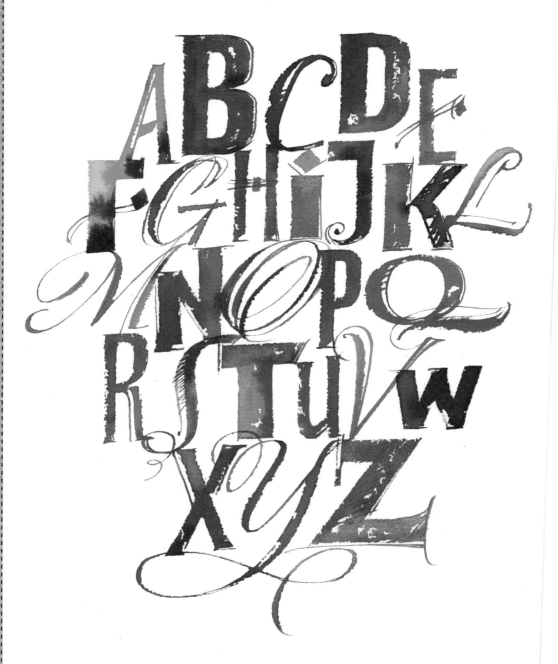

PART III

Creative Hand-Lettering

Fun with Letters & Numbers

Nicknames, quotes, meaningful dates, notes of congratulations, and birthday wishes are all made up of numbers and letters, and they are some of the best things to create in a fun lettering design. Use the ideas that follow as inspiration to get creative with lettering.

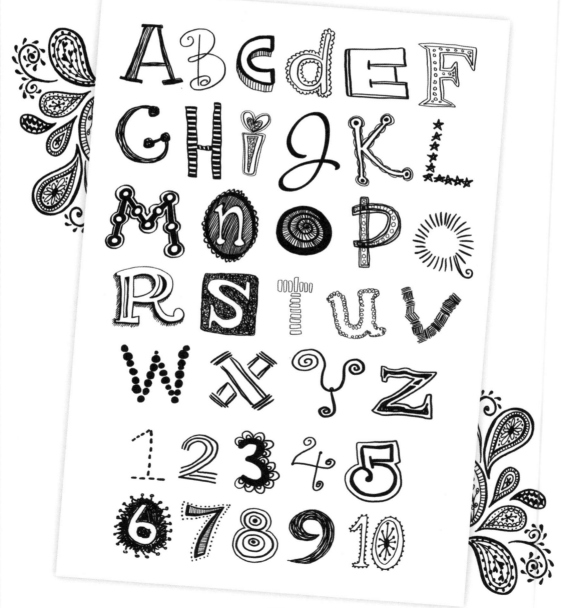

FLOWERS

WOOD

flourishes

STARS

NAILS

STRIPED

STENCIL

SKETCHY

PATTERNED

PUFFY

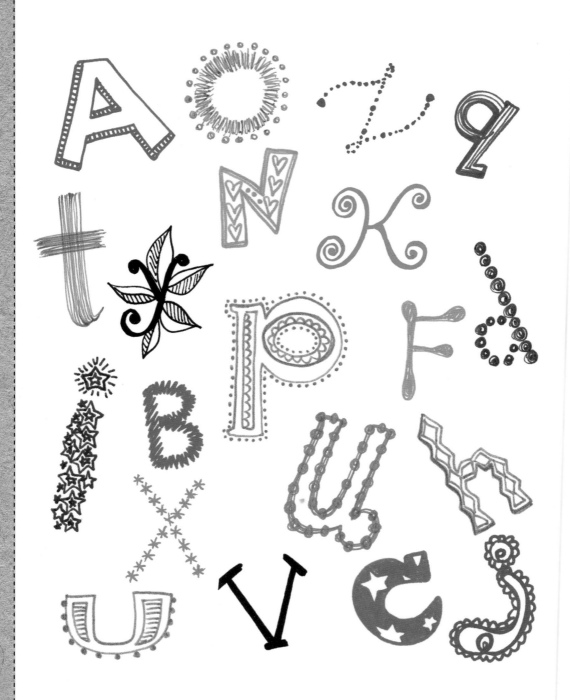

PRACTICE HERE

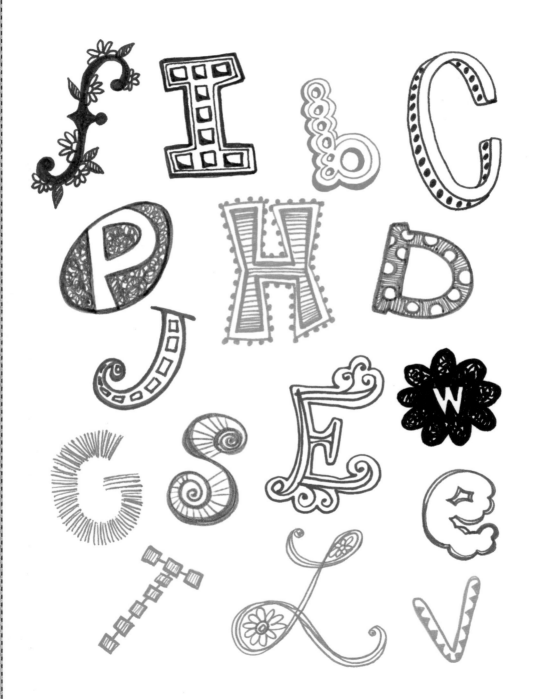

PRACTICE HERE

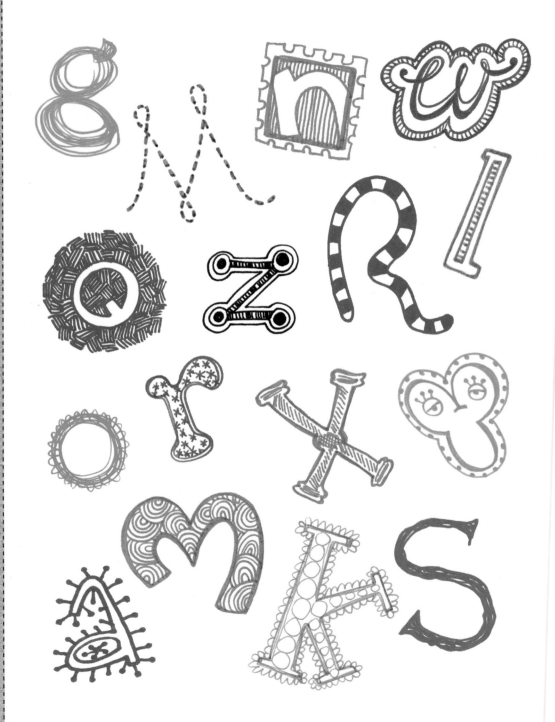

PRACTICE HERE

Doodled Letter Composition

The objective for this lettering exercise is to create a clustered composition using a single letter and a themed grouping of doodles to embellish it. You might select items that start with that letter or perhaps doodle the favorite things of the person whose initial you choose.

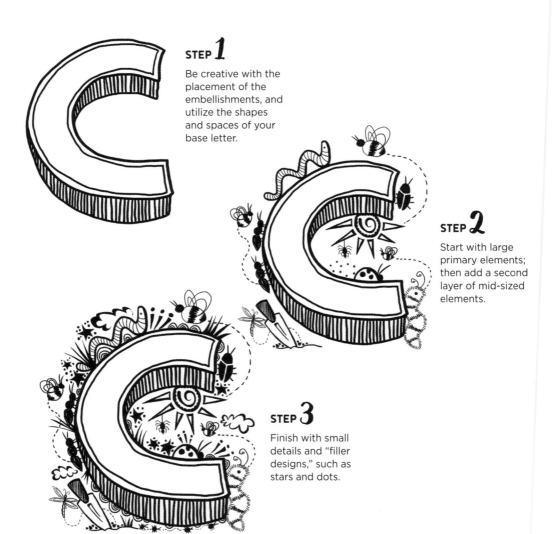

STEP 1

Be creative with the placement of the embellishments, and utilize the shapes and spaces of your base letter.

STEP 2

Start with large primary elements; then add a second layer of mid-sized elements.

STEP 3

Finish with small details and "filler designs," such as stars and dots.

PRACTICE HERE

Doodled Number Composition

Create a sequential, vertical composition using numbers. Each number should have a unique shape and form. The idea is to nestle these shapes together into a tight, artistic arrangement.

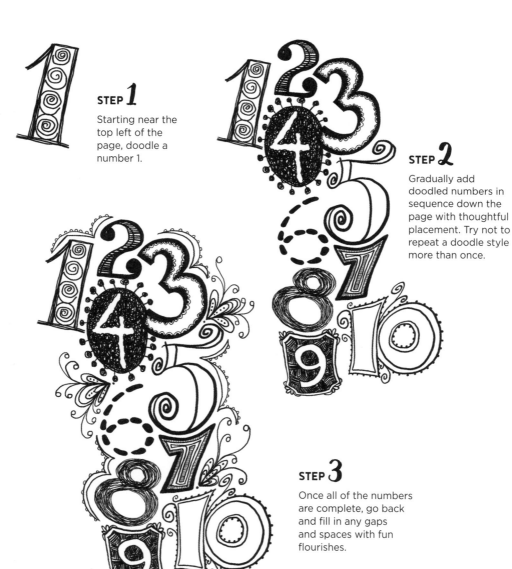

STEP 1

Starting near the top left of the page, doodle a number 1.

STEP 2

Gradually add doodled numbers in sequence down the page with thoughtful placement. Try not to repeat a doodle style more than once.

STEP 3

Once all of the numbers are complete, go back and fill in any gaps and spaces with fun flourishes.

PRACTICE HERE

PRACTICE HERE

PART IV

Lettering Projects

Brush-Lettered Wall Art

Brush lettering is a great technique for creating bold works of wall art.

MATERIALS

- Watercolor paper
- Pencil
- Medium and small paintbrushes
- Gouache paints

STEP 1

Begin by selecting a quote and creating a rough sketch on watercolor paper.

STEP 2

Pick your paint and load your brush. To achieve the brush-lettering look, you want the brush to be on the dry side for added texture. Begin to letter by going over your pencil sketch one letter a time.

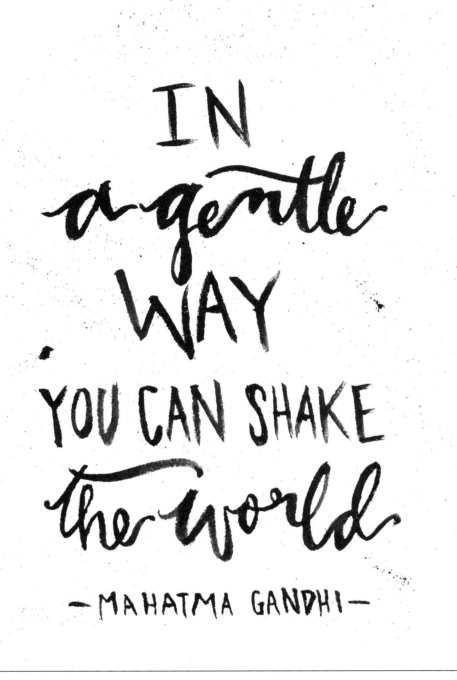

IN
a gentle
WAY
YOU CAN SHAKE
the world

— MAHATMA GANDHI —

STEP 3

When you have finished going over the lettering, add a dash of character with the splatter technique. Load a wet brush with paint, and use your finger to flick the tip of the brush over the paper.

Watercolor-Lettered Wall Art

Brush lettering can stand on its own, but if you are looking for a way to kick it up a notch, you can add watercolor illustrations.

MATERIALS

- Watercolor paper
- Watercolor paints
- Paintbrushes

THE GREATEST PLEASURE IN LIFE IS DOING WHAT PEOPLE YOU SAY CANNOT

STEP *1*

Select a quote, and begin to brush letter. You can pencil it on the paper beforehand, but watercolor paint will not completely cover the pencil marks. Keep your wrist loose to create an easier, more natural look.

STEP *2*

Next start adding the first layer of an illustration around the border, such as a simple botanical border.

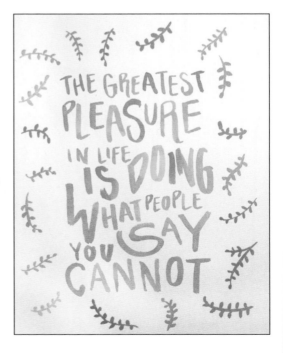

THE GREATEST PLEASURE IN LIFE IS DOING WHAT PEOPLE YOU SAY CANNOT

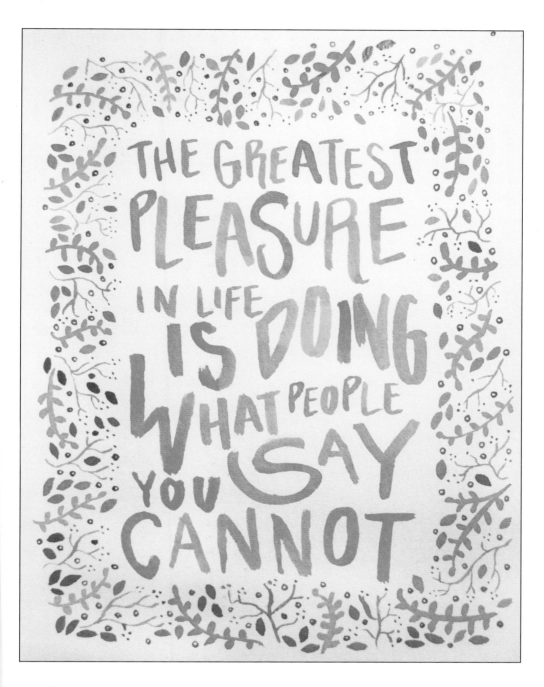

STEP 3

Build up the illustration in layers, pausing often to check the balance. Let the paint dry completely before framing or hanging your new artwork.

Gouache & Watercolor Wall Art

Unlike traditional watercolor paint, gouache has varying degrees of opaqueness. This allows you to paint over—and obscure—other layers of paint. When you study watercolor painting, you learn to plan your painting in layers, starting from light to dark. Working with gouache allows you to take your paintings to a new level with an added degree of depth. Try pairing watercolor backgrounds with different colors of gouache for a stunning effect.

MATERIALS

- Watercolor paper
- Watercolor paint
- Gouache paint
- Paintbrushes

STEP 1

Choose a shape for the background of your artwork, and paint the shape with water on watercolor paper.

STEP 2

Add watercolor paint, but don't go all the way to the edge of the shape. The wet paint on wet paper creates a feathered ombré look.

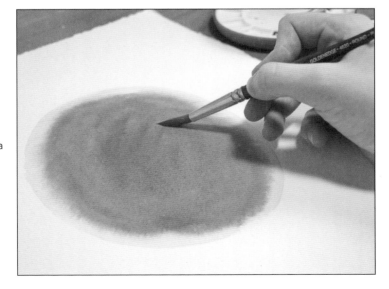

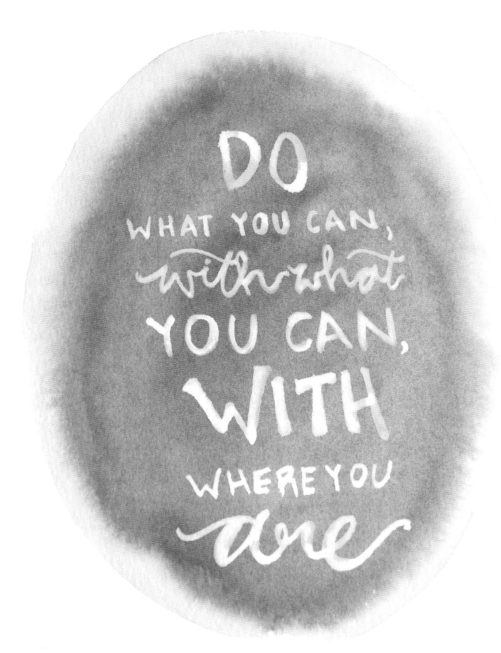

DO WHAT YOU CAN, with what YOU CAN, WITH WHERE YOU are

STEP 3

Let the watercolor paint dry. Select a quote, phrase, pattern, or design (like this quote inspired by Theodore Roosevelt). Then choose a contrasting color of gouache paint, and paint away. Allow the paint to dry.

TIP

Sketch or practice your lettering or artwork on another piece of paper before you begin applying the gouache.

DETAILED BACKGROUND

Now that you've had some practice, take it to the next level by creating a more complicated background with greater detail.

STEP 1

Begin with a light wash of your base color, using watercolor paint. To create a night sky, begin with a wet wash, blending different blues, a little black, and a touch of violet on wet paper. To create the starry effect, scatter salt across the top half of the page. Wait for the paint to dry completely, and then gently brush the salt off with your hand.

STEP 2

Next begin to layer the bottom half of the painting, using black watercolor paint with varying amounts of water to create the illusion of hills stretching out into the distance. Allow the paint to dry completely between each layer, or the layers will bleed into each other.

TIP

Salt is a great way to add texture to watercolor paint and is perfect for suggesting stars or snow!

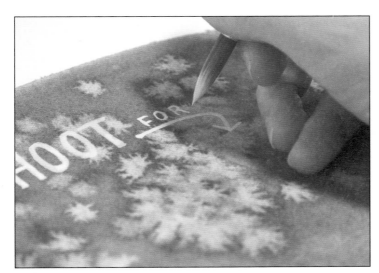

STEP 3

Let the background image dry completely. Then rinse your brush, and use white gouache to letter a quote or phrase of your choice.

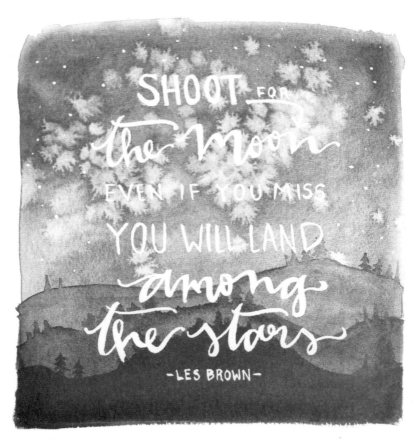

STEP 4

To complete the effect, dot a smattering of stars around the letters. Then step back, and enjoy your work!

Digitizing Your Lettering

Open yourself up to a whole new realm of opportunity by digitizing your lettering and illustrations. All you need is a camera, a computer, and the photo-editing software of your choice. Once you learn to convert your work to a digital format, you can create any number of interesting projects.

MATERIALS

- White foam core board
- Digital camera (preferably a DSLR)
- Tripod (optional)
- Computer & photo-editing software
- Artwork

HOW TO SET UP YOUR PHOTO SHOOT

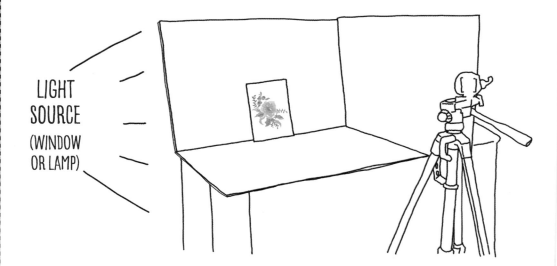

LIGHT SOURCE (WINDOW OR LAMP)

STEP *1*

Follow this illustration as a guide to set up your photo shoot. Choosing the light source is the most important thing. Natural light, such as an open window, works best. If that's not available, don't worry! You can purchase a full-spectrum light bulb or even tweak the white balance on your camera to achieve good light. Position the light source to the side so that it can reflect off the foam board and light up your subject.

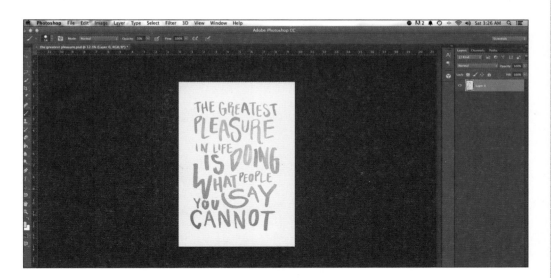

STEP 2

Once you snap a couple of good photographs and load them onto your computer, you are ready to start editing. Select your favorite image, and open it in your photo-editing software, such as Photoshop®.

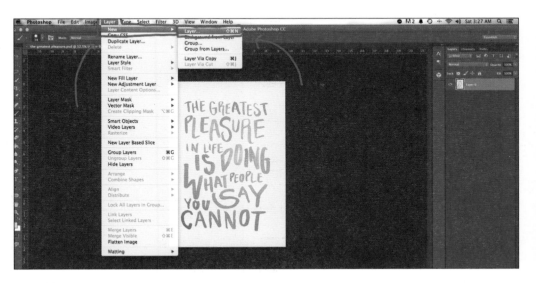

STEP 3

Create a new layer. To do this in Photoshop, click on "Layer," "New," and then "Layer."

STEP 4

In the layers palette on the side, click on the new layer, and drag it down below the original image layer.

STEP 5

In the top menu, click on "Select" and then "Color Range" to open the "Color Range" window.

STEP 6

Use the eyedropper tool to click on the background of the picture.

STEP 7

Once the background is selected, use the fuzziness slider to increase or decrease the contrast and the number of pixels selected. This determines how sharp the letters or illustration will look once you delete the background.

STEP 8

When you are satisfied, hit the delete key on the keyboard, and the background will disappear.
Go back up to "Select" in the top menu, and click "Deselect."

STEP 9

Click on the top box of the color selector at the bottom of the toolbar. The color selector will open, and you can choose a background color.

STEP 10

Click on the layer you created in step 3 (Layer 1). Using the paint bucket tool, click on any part of the background to insert the new background color.

If you would like to be able to insert or drop your illustration over a different background, click on the small eye icon next to Layer 1 to make it invisible. Then save your work.

Open the new background image, and drag and drop your illustration file onto the new open file to create a new layer. You can customize the size and placement of the illustration. Then save your work!

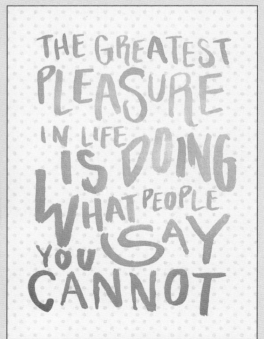

Watercolor Gift Tags

Combine your skills to create colorful, whimsical tags using a watercolor wash and coordinating ribbon—perfect for gift-wrapping!

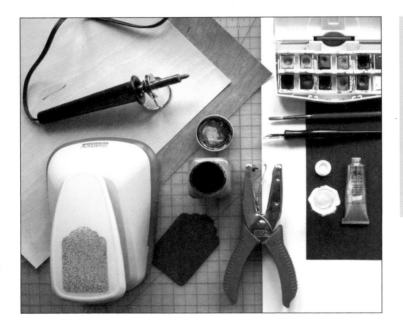

MATERIALS

- Watercolor paints and paintbrush
- Watercolor paper
- Black ink
- Calligraphy pen and nib
- Ribbon
- Gift wrap
- Craft punch (optional)

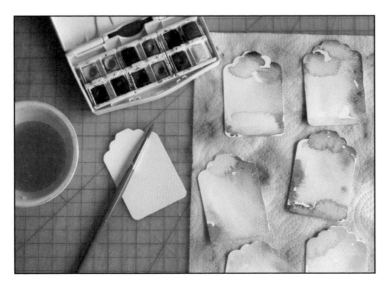

STEP *1*

Punch or cut gift tags from watercolor paper. Then create a watercolor wash on each tag by loosely brushing paint over the paper. To create marbled swirls and avoid an overly pigmented tag, apply plenty of water to the paper as you work.

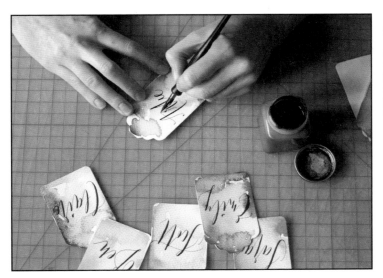

STEP 2

Allow the paint to dry completely. Then, using black ink, add the name of the gift's recipient in calligraphy over the watercolor wash.

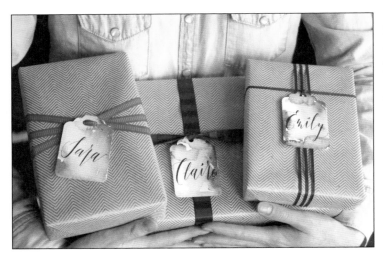

STEP 3

Punch a hole in the tag, and feed ribbon through it. Wrap your gift, and adorn it with the personalized tag and ribbon.

TIP

Pairing tags with coordinating ribbon makes each gift unique and allows you to further personalize the gift by using the recipient's favorite colors.

PRACTICE HERE

About The Authors

CARI FERRARO has been practicing calligraphy for more than three decades and has studied with many of the finest calligraphers teaching today. Her design business, Prose and Letters, has fulfilled calligraphy commissions for weddings, corporations, institutions, and individuals since 1982. She also maintains a website as an online portfolio and catalog of her cards, prints, books, and wedding certificates. Cari makes her home in Northern California. Learn more at www.proseandletters.com.

JOHN STEVENS is an internationally known calligrapher, designer, and lettering artist with 30 years of experience. An art major and former musician, he found his true calling when he was introduced to lettering while apprenticing in a sign shop. Immediately hooked, he diligently studied letterforms, letterform design, typography, calligraphy, art, and design, scouring libraries to find everything he could get his hands on. John started a business as a freelance letterer and designer in the early 1980s creating lettering, calligraphy, and logo design for publishing companies and other businesses. John's prestigious client list includes Rolling Stone, Time, Readers Digest, and Newsweek magazines; Pepsi; Atlantic Records; HBO; Lucasfilm; Universal Studios; Macy's; Bergdorf Goodman; IBM; Disney; and Bloomingdales, among others. Originally from New York, he now lives in Winston-Salem, North Carolina, where he has been a faculty member of The Sawtooth Center for Visual Art and is an exhibiting member of Associated Artists. He also teaches and is the faculty advisor and marketing director at Cheerio Calligraphy Retreats, a biannual retreat in the Blue Ridge Mountains. Learn more at www.johnstevensdesign.com.

OTHER CONTRIBUTORS

STEPHANIE CORFEE is a full-time freelance artist and designer living in Malvern, Pennsylvania. She has worked in advertising and marketing and previously owned her own wedding gown design studio. Today Stephanie enjoys the creative freedom that comes from owning her own business while doing what she loves. She has a colorful, bohemian personal aesthetic and loves creating fun, whimsical art for children. Visit www.stephaniecorfee.com.

GABRI JOY KIRKENDALL is a self-taught artist and the creator behind Gabri Joy Studios. She specializes in hand lettering, but she also works with pen and ink, watercolor, and mixed media. Her art graces homes not only in the Pacific Northwest, where she lives and works, but also has traveled around the world to clients and fellow enthusiasts in far-flung climes such as England, Spain, Canada, New Zealand, and Australia. Gabri's work has also been featured and sold by companies such as Threadless and in local art galleries. She finds joy in volunteering her time as an independent business consultant helping others fulfill their dreams of entrepreneurship. To learn more about Gabri and her current projects, visit www.gabrijoystudios.com.

JULIE MANWARING has long loved the whimsical, rhythmic beauty found in the repeating letterforms and flourishes of calligraphy. Her custom hand-lettering and illustration studio, Flourish & Whim, grew out of this love for letters and passion for art. Julie's styles are a unique blend of classic and modern—the perfectly imperfect ups and downs, swirls, and undulations create a graceful dance of words. Hailing from the Northeast, Julie currently lives in San Francisco with her family of three. When not in the studio, she can be found swinging at the playground with her son, strolling through the neighborhood fabric shop, or combining efforts with her husband on a new pizza recipe in the kitchen. To learn more about Julie and her work, visit www.flourishandwhim.com.